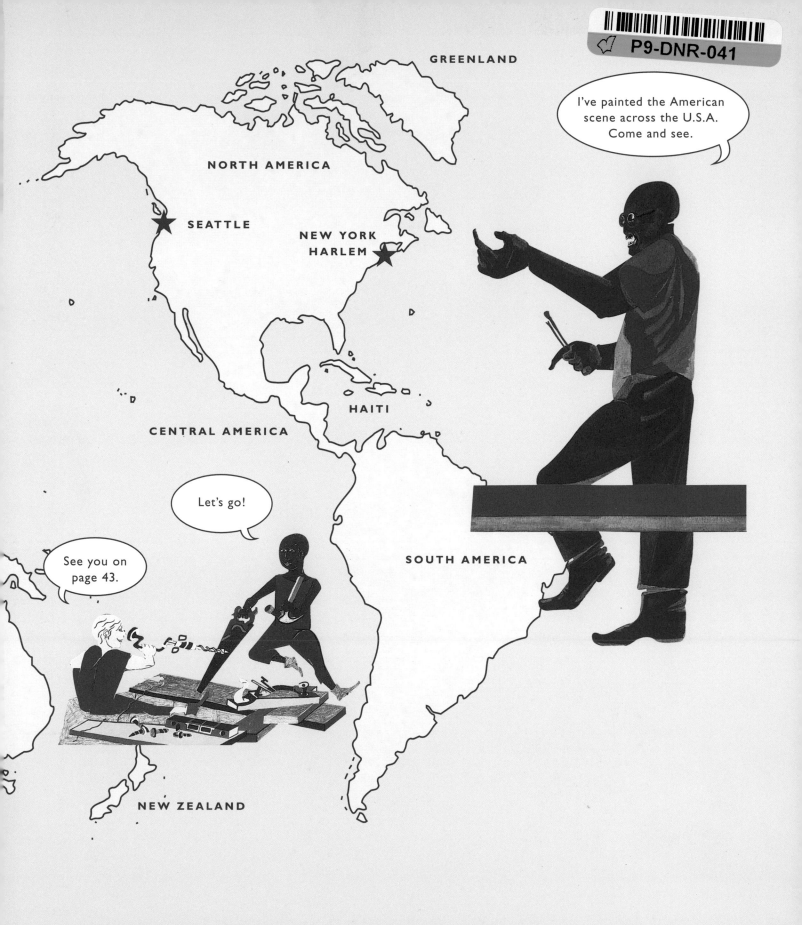

See you on page 43.

Jacob Lawrence

American Scenes, American Struggles

Nancy Shroyer Howard

Davis Publications, Inc.
Worcester, Massachusetts

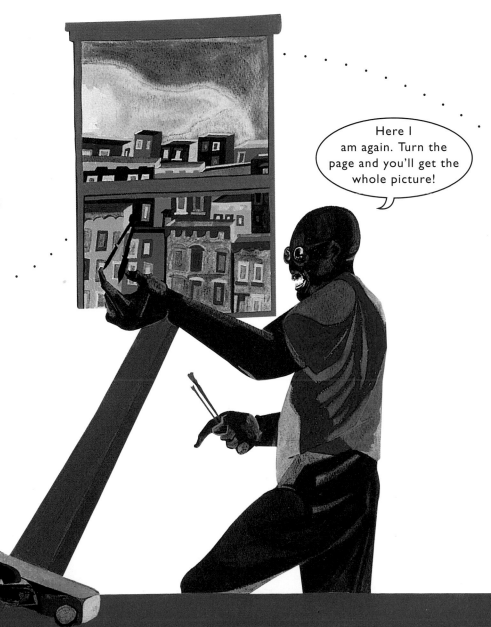

With gratitude to
Jacob and Gwendolyn
Lawrence.

Editor: Martha Philippa Siegel
Design: Susan Marsh
Production Editor: Nancy Burnett

Library of Congress Catalogue
Card Number: 95-071796
ISBN: 0-87192-302-5
10 9 8 7 6 5 4 3 2 1
Printed in Hong Kong

Cover: Jacob Lawrence, *Builders –
Man on Scaffold,* 1985 (detail).
Courtesy of Francine Seders
Gallery, Ltd., Seattle, Washington.

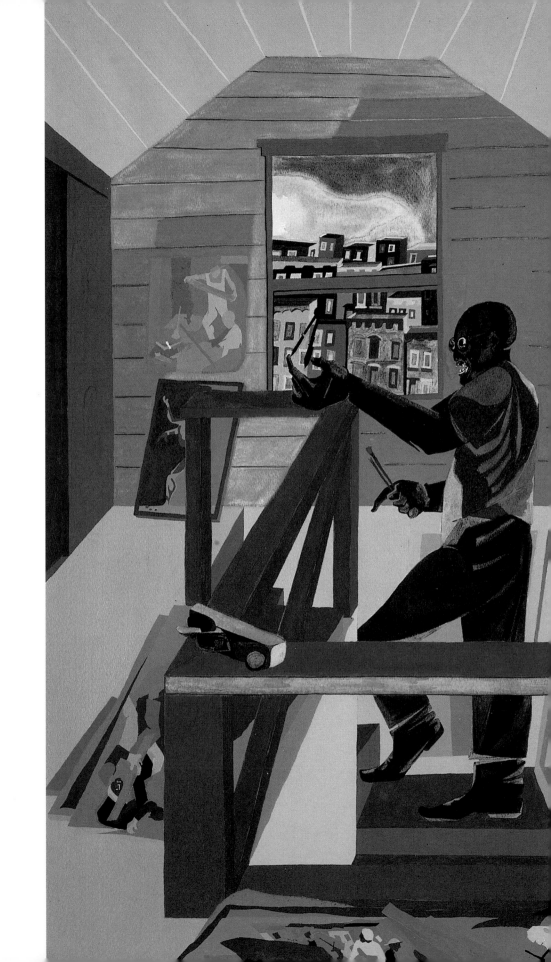

Let's Go!

Meet Jacob Lawrence, a masterful artist of twentieth-century America. He was born in New Jersey in 1917, grew up in Harlem, New York, and now lives in Seattle, Washington.

This book takes you into the stories and struggles of African Americans — and of the United States as a whole — from the early days of slavery to the more recent celebrations of today.

(For more information about Jacob Lawrence, his life and work, turn to page 46.)

In this book, you will find three types of activities for exploring paintings and prints by Jacob Lawrence:

1. Quick activities are first, in big letters like this.
 ■ Look for the red squares to guide you.

2. Further explorations come next, in smaller letters.
 ■ Look for the gold squares to guide you.

3. Projects going deeper are in little letters like this.
 ■ Look for the green squares to guide you.

Look for things that Jacob Lawrence has said in slanted letters like this.

↖ Jacob Lawrence painted a picture of himself in his studio.

To see how it all began, turn the page. →

The Studio, 1977.

Where is everyone going?

Just before Jacob Lawrence was born, African Americans began leaving the southern part of the United States by the thousands.
The men, women and children hoped for a better life in the North.

■ Look at who is taking a train ride north.

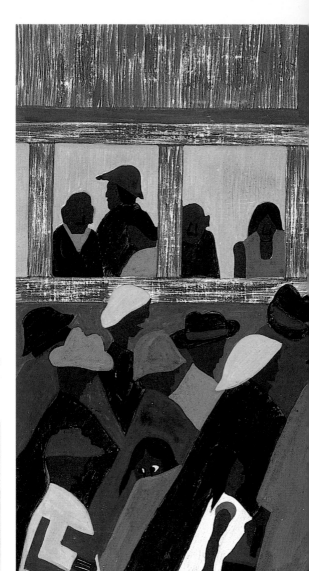

Who is stepping into a railroad car?

Who will try to sit next
to this person?
↓

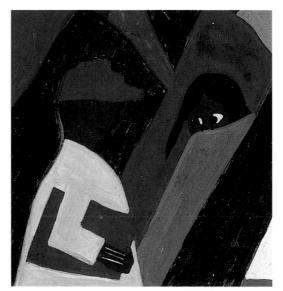

Who is making sure her
brother isn't left behind?

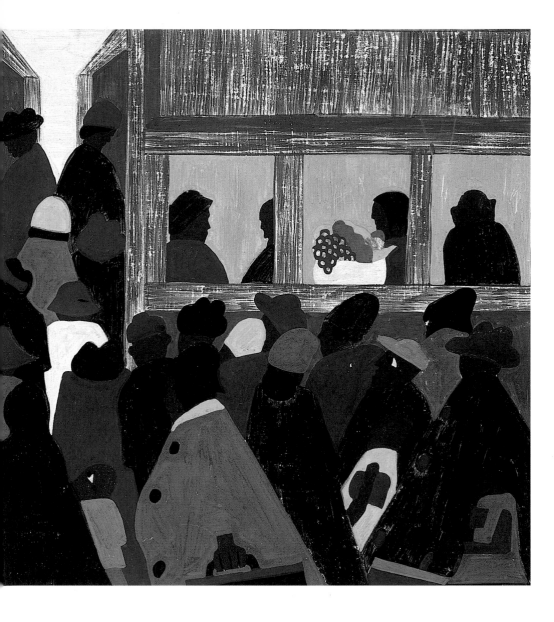

Jacob Lawrence's mother told stories about her own train ride north. Jacob remembered them.

It was my family. It was me. It was part of my life.

Many years later, he painted *sixty* scenes of families moving north!

(This one is number 23 in the Migration Series.)

Here's how Jacob showed the train:

First, he painted a board white.

Over that, he painted the train with thin, dry brushstrokes of color so that the white paint shows through.

He painted the people in thick, solid colors.

↖ Find the places where he used thin paint and thick paint.

■ What's the rush?

Everyone is rushing to get on the train and head for a better life up north — better jobs, better places to live and better education. How does the artist show this?

• Look for people who crowd together to get aboard.
• Look for people who lean forward, eager to go.

Jacob Lawrence's mother traveled from the South to Atlantic City in the North.

In Atlantic City, she met Jacob's father. Jacob was born there. Later, the family moved to Philadelphia.

When Jacob was ten years old, he lived with a foster family while his mother moved to New York City to find a job. She had become a single parent.

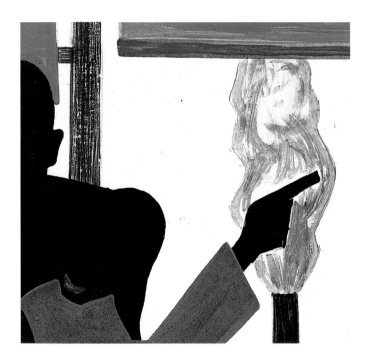

■ Can you see how Jacob shows people feeling hopeful about a new life in the North? →

(This is number 45 in the *Migration Series*.)

• Someone pulls up the window shade.
• A baby forgets her bottle and looks outside.
• A girl sees the factories working full blast.
• A man turns to his wife and smiles.

Maybe there will be good jobs in the North.

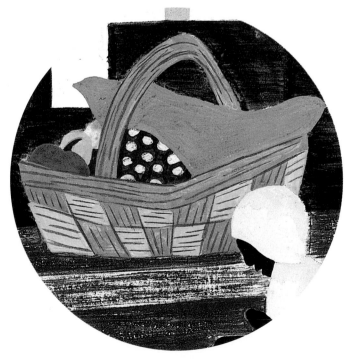

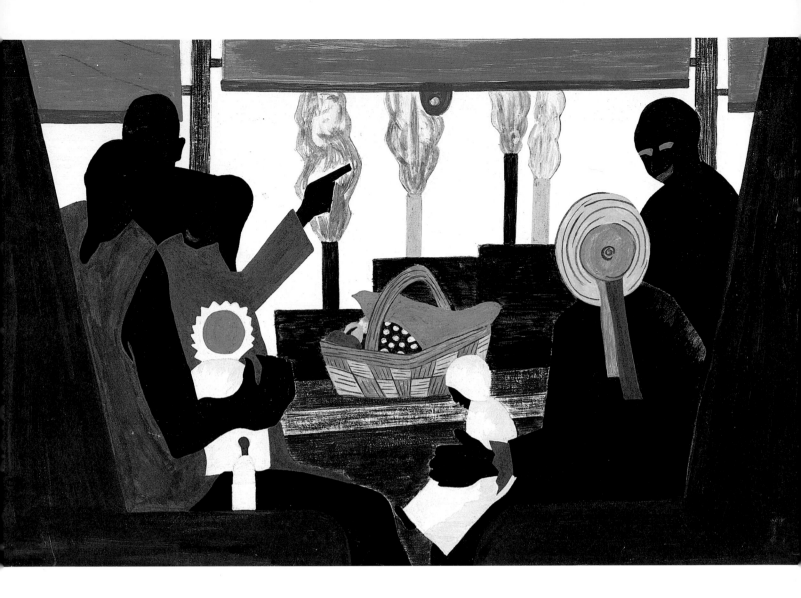

← ◼ Bringing a picnic is a good idea, right?

Compare how Jacob painted the lunches here
and on page 2.

How does he use his brush to show that the
lunch here is carried in a basket?

On page 2, how does he show that the lunch is
carried in something smooth? (Is this lunch carried in
a bowl? Or is it sitting in a smooth basket? It's hard to tell.)

◼ Pack a picnic!

With paper and pencil,
draw picnics you would
take on a train ride.
• Good things to eat.
• Something to drink.
• Colorful napkins.
• Will your picnic be
 packed in a basket?
 A backpack? A cooler?
 A barrel?

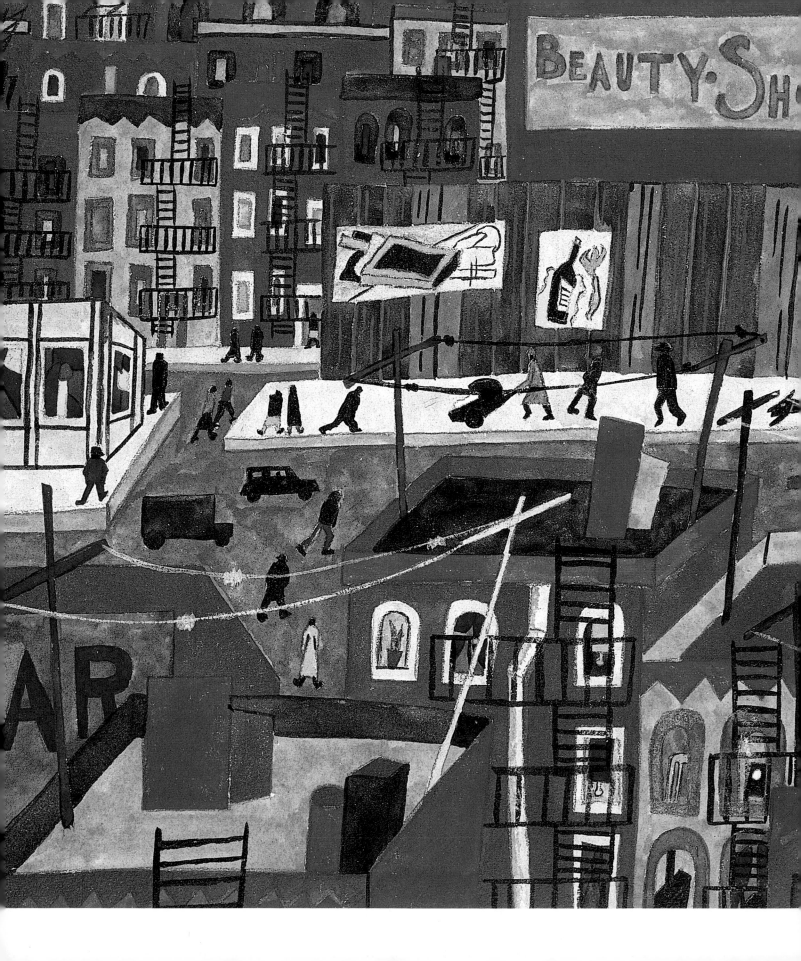

Jacob joined his mother in New York City in 1930. They lived in a neighborhood called Harlem.

Jacob was thirteen. Harlem was exciting.

The country was going through the Great Depression, [but] there was a warm community spirit in Harlem at the time. . . a spirit of uplift.

As a young man, Jacob began to paint scenes of Harlem life. (He still does that today.)

■ What's going on here, in Harlem? Find:
• a baby carriage.
• kids running.
• clotheslines on roofs.
• 1940s cars.
• and. . .?

Race you to the corner!

■ Search for things Jacob loved:
• **patterns** (repeated lines or shapes in the rungs of the ladders, the boards on the walls, the rows of windows, and. . .).
• **colors** (name them all). • **movement** (driving, pushing, and. . .).
• **shapes** (rounded, straight, and. . .).

I built street scenes inside corrugated boxes. . . taking them to familiar spots in the street and painting houses and scenes on them.

■ **Make a scene!**

Create a street scene inside a box, the way Jacob did when he was a teenager. Open up a box. Go outside and look around.
Then draw or paint buildings, windows and trees on your box — whatever you see and like. Add some people.

This is Harlem, from the *Harlem* series, 1942–43.

Jacob Lawrence loved the Apollo Theater in Harlem.

We would go there to see the comedians, the chorus lines, the dance performance.

■ Find how Jacob shows one act following another, from dancers and musicians to comedians. Look for: →
- the green curtain rising and falling.
- figures disappearing, cut in half.
- patches of floor boards, patches of blue.

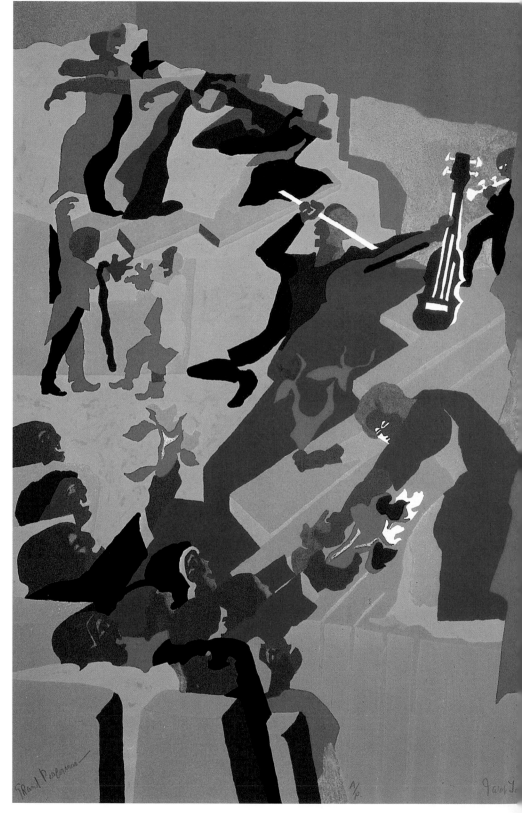

Grand Performance, 1993.

■ **Take a closer look.**

Hold your hands together to make a small picture frame, like this. Move your hands over the picture to frame ← small parts of the painting. Find how Jacob shows people in motion:
- dancers lunging forward.
- comedians reaching high.
- a singer bending forward.
- the audience offering roses.
- and more. . . .

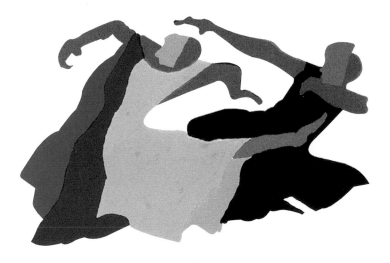

■ **What's all the excitement about?**

Jacob wants to show you the fun and *spirit* of the Apollo, not exact details. So, Jacob's scenes do not always look like real life. Sometimes they do, sometimes they don't.
- **Find the entertainers who are standing on solid ground.**
- **Then find the ones who are floating.**
- **Find the faces that look real.**
- **Then find just shapes of heads.**

Jacob also loved museums.

When he was a teenager, he often walked sixty blocks to the Metropolitan Museum of Art. He liked the ancient Egyptian art on exhibit there.

Jacob found magic in all kinds of art — African, European, North American and Central American art.

Three or four of us would go around to the museums and exhibitions and stop at the Automat and discuss our experience. It was a wonderful education.

Jacob was really excited about an exhibit of West African sculpture that he saw at the Museum of Modern Art in 1935.

"Professor" Seyfert, a teacher who once was a carpenter, made sure that Harlem artists saw the exhibit. Jacob was so thrilled by the art that he went home and whittled two sculptures in wood.

The show was very powerful for a lot of us — taught us about another kind of beauty. . . . When you look at African sculpture you see the beauty.

Harlem became crowded.
Rents went up
and jobs were scarce.
It was 1930.
Harlem was poor.

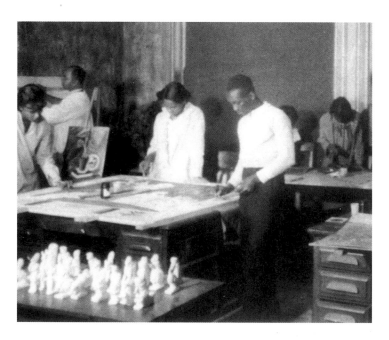

Even though a Pepsi cost only five cents, times were tough.

Jacob's mother found work in peoples' houses, but often the family lived on welfare. Jacob had jobs too: in a laundry, at a printer's shop and on a paper route.

←

Jacob joined the Harlem Art Workshop in 1935. It was free. He could spend hours there.
(He's in front, wearing a white sweater.)

→

Two outstanding Harlem artists helped and encouraged Jacob: Charles Alston, a painter, and Augusta Savage, a sculptor.

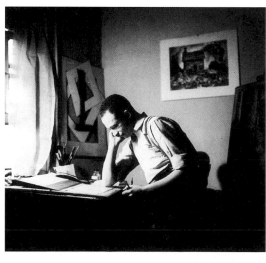

Jacob often disappeared into the public library.

There, he could read armloads of books, take art classes, hear stories and see African art.

It became a living experience for us. . . a very important part of my life.

 ■ Let your hand walk through the library. ↙

Stop at:
• a tiny African statue.
• the *most* popular, rumpled books.
• two kids talking behind one book.

■ Find bright colors for the books and people. Find darker colors for the quiet room.

Make a picture of a room in the library you know best. What parts should be brightest? What parts should be darker?

I would hear stories from librarians about various heroes.

■ **Think about heroes!**

Jacob spent hours reading about these heroes. Can you tell any of their stories?
• **Toussaint L'Ouverture**
• **Frederick Douglass**
• **Harriet Tubman**
• **John Brown**

Jacob painted *all* their stories. You'll see.

Schomburg Library, 1987. This painting was named for the New York Public Library located at 135th Street. It has an enormous collection of African and African-American art and writings.

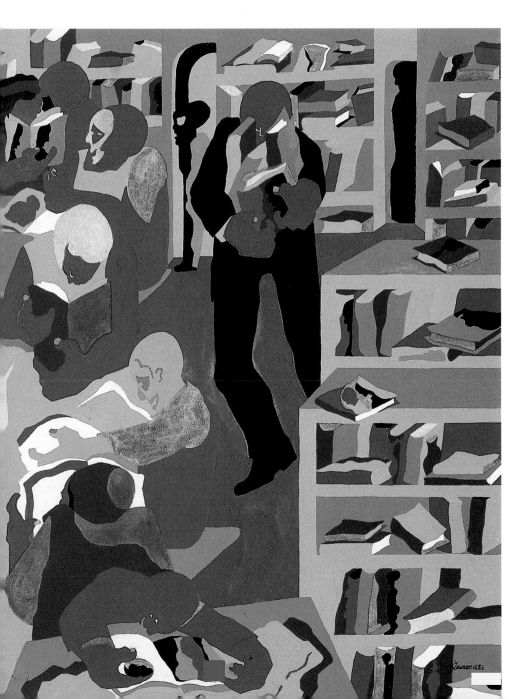

11

One of Jacob's heroes is the man who freed Haiti from slavery, Toussaint L'Ouverture.

(Say too-SAN LOO-ver-TOOR).

I was really inspired by what I found in those books and I wanted to try to record this tremendous story with brush and paints.

Jacob painted forty-one scenes from Toussaint's life and wrote about him below each one.

(Here are four of them, numbers 6, 10, 20 and 34.)

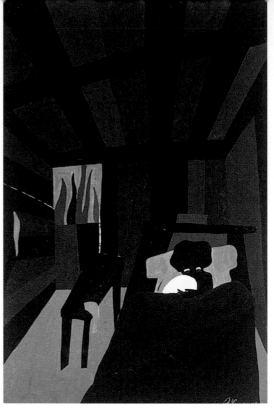

6. The birth of Toussaint L'Ouverture, May 20, 1743.

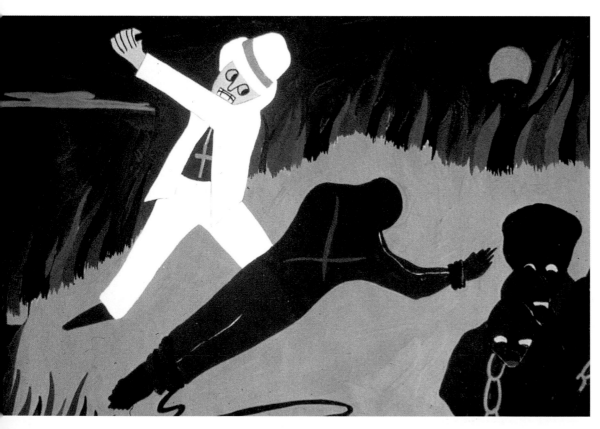

I wanted to tell a story. . . . The only way, then, was with murals. I didn't have the experience to do murals. . . so I did it in panels.

10. The cruelty of the planters led the slaves to revolt, 1776. These revolts kept cropping up from time to time — finally came to a head in the rebellion.

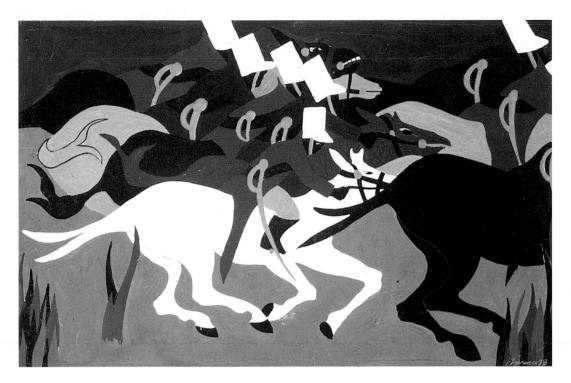

I was praised and told that what I was doing had some value — by writers, other artists, teachers, librarians. It gave me a sense of value, right in the Harlem community.

34. Toussaint defeats Napoleon's troops at Ennery.

Toussaint was born a slave in a simple cabin on the island of Haiti. People had been kidnapped in Africa and sold as slaves to French farmers (planters) in Haiti. The French wanted slaves to work in the fields of their large farms (called plantations).

Jacob Lawrence shows how sometimes the slaves were chained together, tied up and beaten. Toussaint led the slaves in a revolt against their masters which ended slavery.

Slaves had no schools, but Toussaint taught himself to read. He learned how to write new laws to govern Haiti.

■ Read Toussaint's story.
←
Then tell his story in your own words, adding details from the four paintings on these pages.

■ Study how Jacob Lawrence painted each horse to show it charging fast ahead.

Draw a speeding horse. If it gallops too slowly, put it out to pasture and draw another one.

■ **Picture your hero.**

In this series of paintings, the artist used poster paint on paper. You can, too.

Choose a man or woman who is your hero. Record a scene with a brush, paint and words

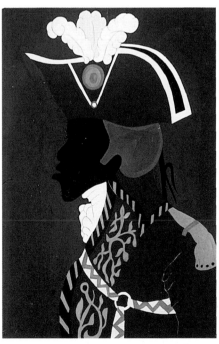

20. General Toussaint L'Ouverture, Statesman and military Genius, esteemed by the Spaniards, feared by the English, dreaded by the French, hated by the planters and reverenced by the Blacks.

13

Next, Jacob painted Frederick Douglass, a slave who became a great American hero.

I don't see how a history of the United States can be written honestly without including the African American.

Jacob Lawrence painted the Frederick Douglass story in thirty-two scenes. He wrote about part of Frederick's life below each scene.

(Here are ten of the scenes, on pages 14–20.)

Frederick was born a slave on a plantation in Maryland. He had a cruel childhood; his mother was sent away to another owner and he never knew his white father. He was put to work when he was just a little boy. He saw slaves, like a child named Millie, being beaten (flogged).
← A whip was always nearby. Slaves lived in fear.

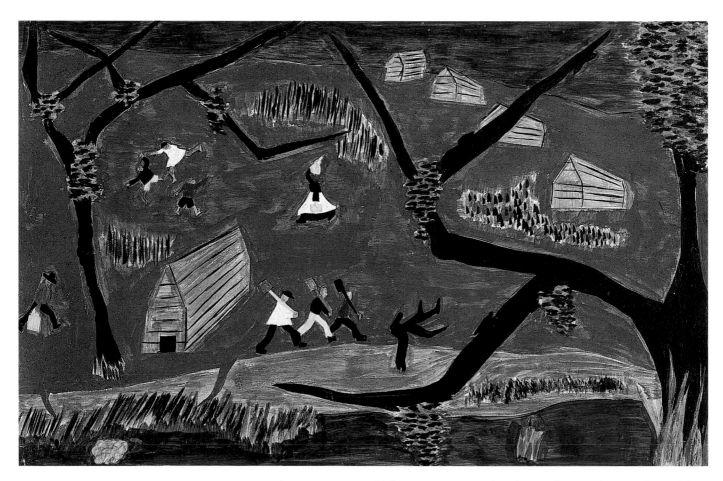

1. In Talbot County. . . Frederick Douglass was born and spent the first years of his childhood — February 1818.

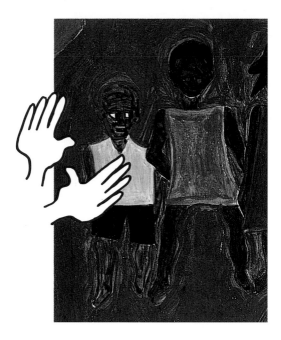

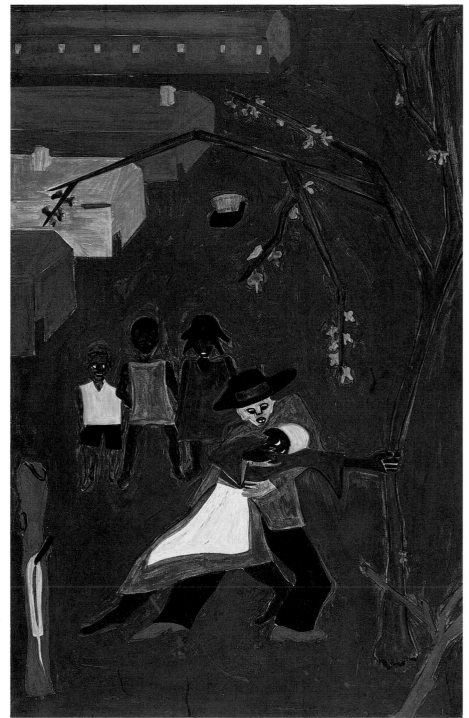

As you follow Frederick's story, here are three things you can do:

■ With your hands, ↑ frame places where you see Frederick. ↗

(His skin was light brown.)

■ Frame the colors the artist chose for:
• daytime. • nighttime.

■ Jacob Lawrence painted these scenes on a hardboard that he coated with a white paint (called gesso). You can see the brushstrokes of colors he used.

Frame textures the artist made by using different kinds of brushstrokes for:
• cabins. • trees. • grass and leaves.
• clothes. • walls. • train cars.

3. When old enough to work, he was taken to Colonel Lloyd's slave master. His first introduction to the realities of the slave system was the flogging of Millie, a slave on the Lloyd plantation.

Frederick wanted to learn to read, but the slave master would not allow it.

Slaves were not allowed to read and write.
They were only allowed to work and obey.

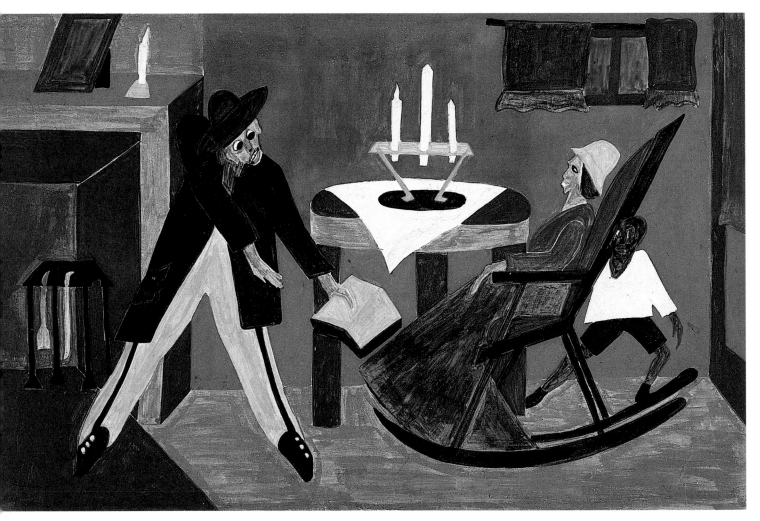

6. Hired out from Colonel Lloyd's plantation, Frederick Douglass arrived in Baltimore at the age of eight. His new mistress, never before having been a slaveholder, consented to his request to teach him to read, to which the master of the house told her the laws of the slave system — one being that a slave must only learn one thing — to obey — 1826.

Secretly, Frederick studied and learned with white friends. Alone, he read about freedom and rights. ↙

Years later, white slave owners said they would kill Frederick if he tried to teach other slaves to read and write. ↓

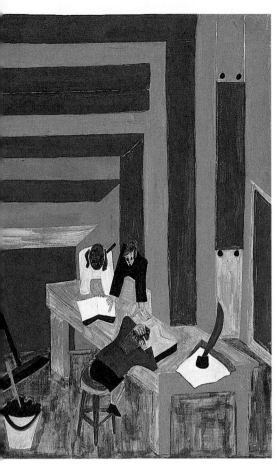

7. Douglass, forced by his master to discontinue his learning, continued his studies with his white friends who were in school.

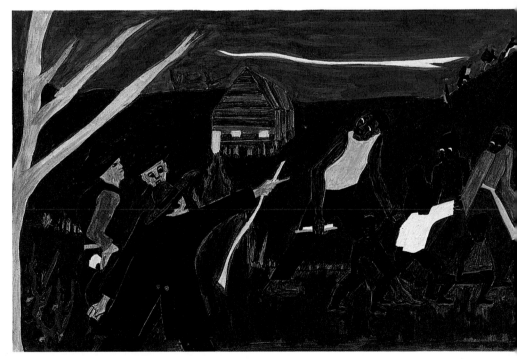

9. Transferred back to the eastern shore of Maryland, being one of the few slaves who could read or write, Douglass was approached by James Mitchell, a free Black, and asked to help teach a Sabbath school. However, their work was stopped by a mob who threatened them with death if they continued their class — 1833.

When slaves did not obey, they were beaten. When they tried to escape, they were often caught.

In a struggle, Frederick fought off a beating (flogging). →

He planned an escape, but was captured.

↓

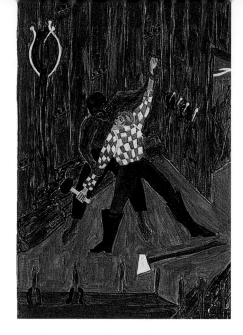

10. The master of Douglass, seeing he was of a rebellious nature, sent him to a Mr. Covey. . . a "slave breaker." A second attempt by Covey to flog Douglass was unsuccessful. . . . He was never attacked again by Covey. . . .

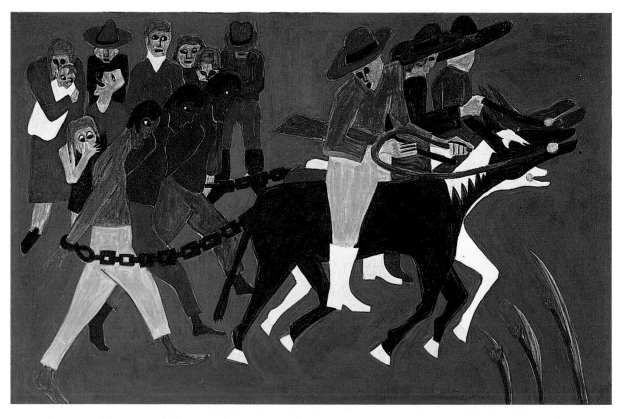

13. As the time of their intended escape drew nearer, their anxiety grew more and more intense. Their food was prepared and their clothing packed. Douglass had forged their passes. Early in the morning they went into the fields to work. At mid-day they were all called off the field, only to discover that they had been betrayed.

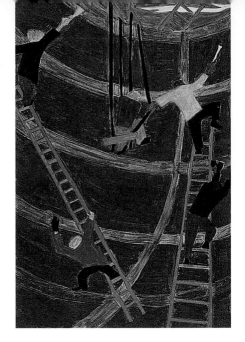

14. Frederick Douglass was sent to Baltimore to work in the shipyards. . . . Douglass had become a master of his trade, that of ship caulker.

↑

Frederick Douglass was taken to work for a company that built boats. He longed for freedom. Finally, he escaped! He pretended he was a sailor, not a slave. He could fool people because he knew boats, inside and out.

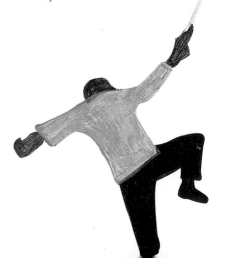

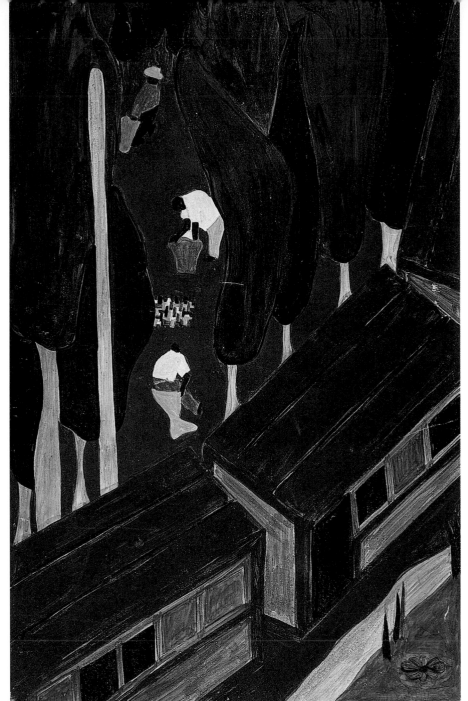

15. Frederick Douglass's escape from slavery was a hazardous and exciting twenty-four hours. Douglass disguised himself as a sailor — best, he thought, because he knew the language of a sailor and he knew a ship from stem to stern. . . .

A train swept Frederick out of the South ↑ to freedom in the North.

Free at last! Frederick Douglass spent the rest of his life working against slavery.

Frederick told people in the North about the evils of slavery. In speeches and newspapers, he urged them to abolish slavery.

Here, Frederick challenges a child to make the future free and fair for everyone. →

Frederick Douglass became a hero to African Americans and to white people who worked to end slavery (abolitionists).

When the Civil War ended slavery in the 1860s, Frederick Douglass helped the freed slaves who were without homes or work.

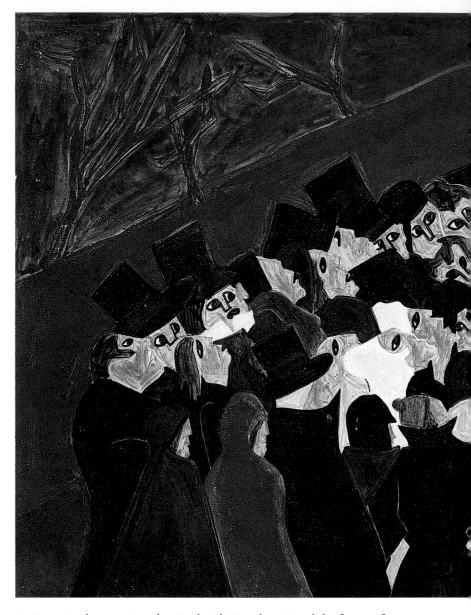

18. It was in the year 1841 that Frederick Douglass joined the forces of William Lloyd Garrison and the abolitionists. He helped secure subscribers to The Anti-Slavery Standard and The Liberator. He lectured through the eastern counties of Massachusetts, narrating his life as a slave, telling of the cruelty, the inhuman and clannish nature of the slave system.

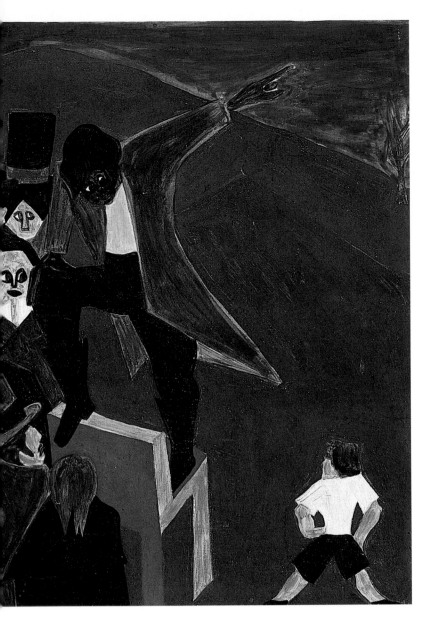

Have you noticed how carefully Jacob Lawrence arranges his paintings?

Look back through the Frederick Douglass story.

■ Find the painting of the plantation.

Show how the artist arranged the trees to frame:
• children playing.
• people going to work.

Show what is:
• near.
• far away.

■ Find the painting with the schoolhouse.

Show how the artist arranged the tree to point away and say "get out"
(just as the man does).

Show how Jacob made some of the people:
• lean away.
• escape into the distance.

■ Find the painting of the capture.

The artist arranged (composed) the picture with no trees, no scenery and no distance to escape into.

Show how the composition creates the feeling (or mood) of being closed in and captured. Find:
• three slaves packed together.
• three bosses on horses, close together.
• a bunch of gawkers.

Compose two pictures of your own that show:
• freedom.
• captivity.

Then came a series of paintings about Harriet Tubman, an escaped slave who risked her life to free others.

When you hear these stories, so passionate, it almost brings tears to your eyes.

Jacob Lawrence painted Harriet's story in thirty-one scenes, and he wrote about her life below each one.

(Here are seven scenes, on pages 22–27.)

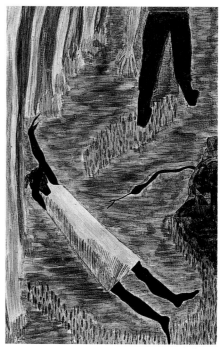

5. She felt the first sting of slavery when as a young girl she was struck on the head with an iron bar by an enraged overseer.

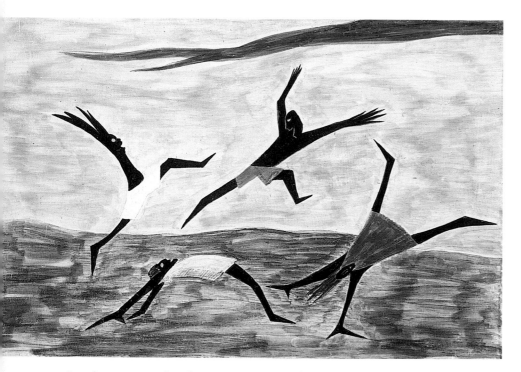

4. On a hot summer day about 1820, a group of slave children were tumbling in the sandy soil in the state of Maryland — and among them was one, Harriet Tubman. . .

Harriet was a slave in Maryland. She was made to do hard labor from the time she was five years old. One day, when the slave master (overseer) was angry, he gave Harriet a terrible hit on the head.

Harriet worked hard. She grew strong and tough. But her head injury made her faint at times. So she was sold to another slave owner. Her dream was to be free.

As you follow the story of Harriet Tubman, here are three things you can do:

■ **Find Harriet in each scene.** (The artist put her in white.)

Describe what she is doing.

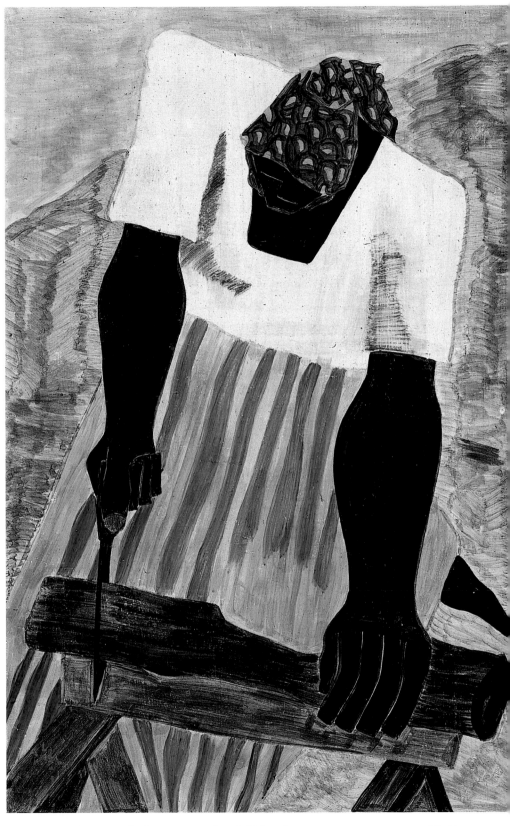

■ Find places where the artist shows:
• a dangerous mood.
• a safe atmosphere.

Describe how he does this.

■ **Be dramatic.**

Each painting is like a scene in a drama. You can see how the artist creates a dramatic mood by posing your body in the same positions as Harriet's body. See if anyone can guess which paintings you are acting out.

7. Harriet Tubman worked as water girl to field hands. She also worked at plowing, carting and hauling logs.

23

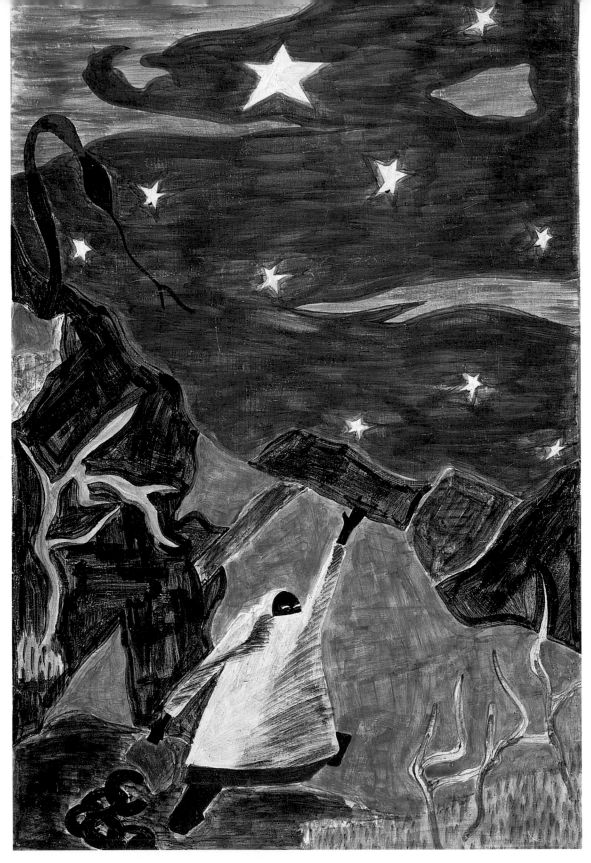

10. Harriet Tubman was between twenty and twenty-five years of age at the time of her escape. She was now alone. She turned her face toward the North, and fixing her eyes on the guiding star, she started on her long, lonely journey.

One night, Harriet Tubman escaped!

It was a dangerous trip to freedom. If caught in the United States, she would be sent back to her owner. That was the law. She would be punished. She might never be free.

To avoid being caught, Harriet walked at night and hid during the day. Following the North Star, she headed for Canada, where runaways were not captured and returned to their owners in the U.S.A.

Scared and exhausted, Harriet finally reached Canada. Then she made secret trips back to the southern part of the United States. Each time she led a few slaves north to safety.

Plantation owners hated Harriet. They had spent a lot of money buying their slaves. They needed slaves to work their fields. They offered money to anyone who could capture Harriet, dead or alive.

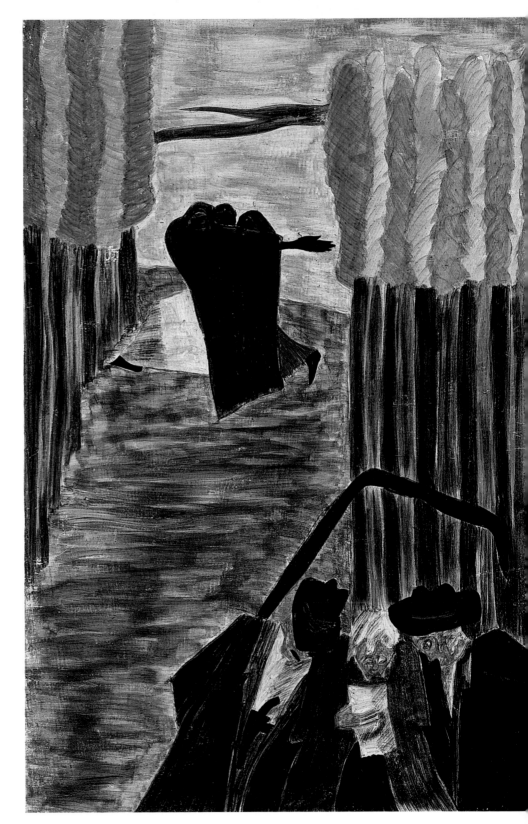

19. Such a terror did she become to the slaveholders that a reward of $40,000 was offered for her head, she was so bold, daring and elusive.

Harriet Tubman rescued more than three hundred slaves.

In the North, Harriet Tubman told hundreds of people about the evils of slavery. She raised money for her secret rescue missions.

She also worked by cooking and cleaning people's houses, saving money for each dangerous trip south.

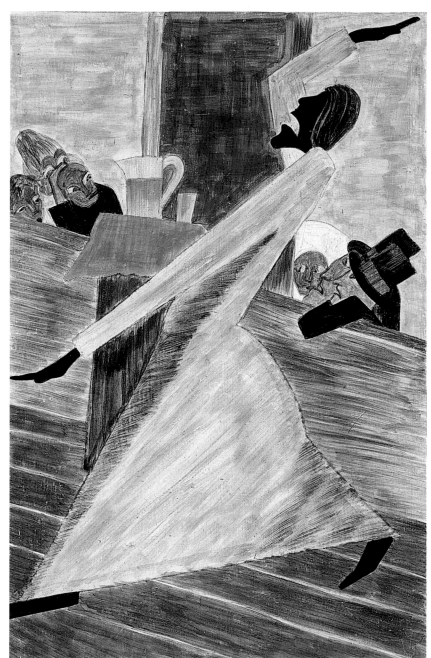

21. Every antislavery convention held within 500 miles of Harriet Tubman found her at the meeting. She spoke in words that brought tears to the eyes and sorrow to the hearts of all who heard her speak of the suffering of her people.

Risking her life over and over again, Harriet traveled secretly from the North to the South and back again. She rescued her parents, most of her brothers and sisters, and dozens of other slaves.

She learned about safe places to hide and rest, called the Underground Railroad. There, she and the exhausted slaves could eat and sleep in peace. In one place, they were given new shoes.

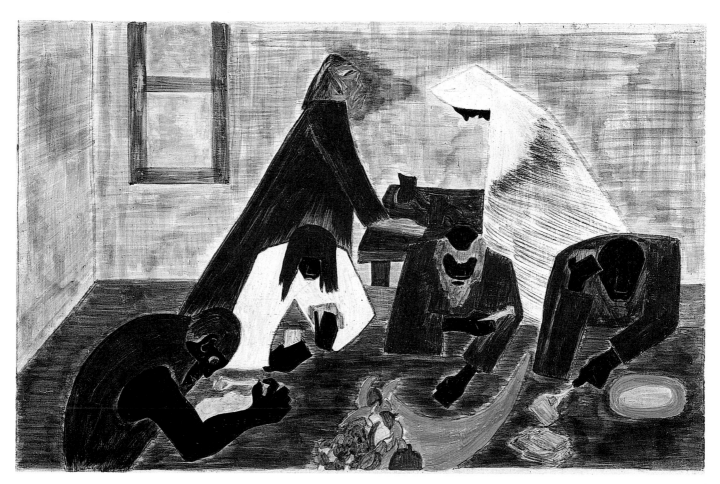

22. Harriet Tubman, after a very trying trip North. . . by boat, wagon, and foot at night. . . met Thomas Garrett, a Quaker who operated an Underground Railroad station. Here, she and the fugitives were fed and clothed and sent on their way.

During the Civil War, Harriet was asked to be a guide and spy for the Union Army. She also became a nurse to wounded soldiers.

Harriet spent the last years of her life in Auburn, New York. When she died, a plaque was placed on the county courthouse, honoring this courageous American hero.

Have you noticed how Jacob Lawrence tells stories using simple objects to express his ideas?

Sssssssss. . .

These symbols are everywhere.

← ■ Look back through these pages to see how these symbols help tell the stories:

• serpents stand for danger.
• the North Star symbolizes hope.
• a whip, hammer and guns mean violence.
• pen and paper represent learning.
• a chain stands for slavery.
• a broken chain symbolizes freedom.

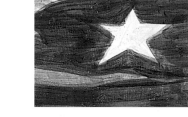

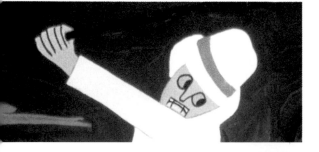

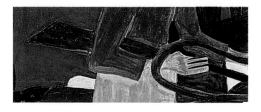

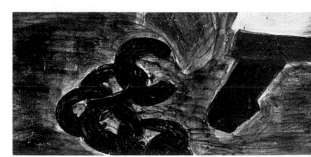

28

← ▢ Look back again to see how the artist shaped bodies to express ideas. Find bodies that show:
- play.
- pain.
- brutality and terror.
- courage and determination.

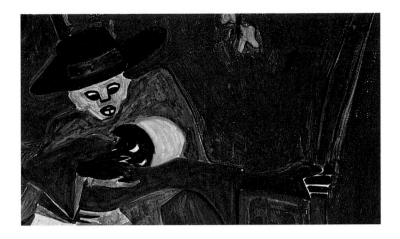

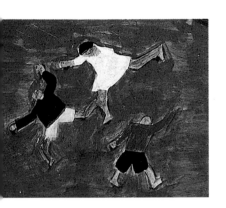

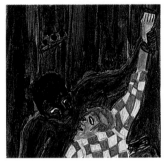

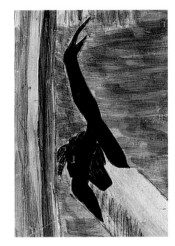

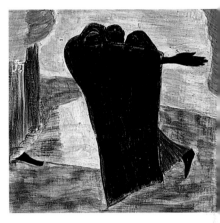

← ▢ Look back to see how bodies become symbols of how life can be:
- fearless.
- healthy.
- educated.
- kind.
- joyful.
- free!

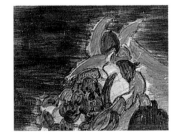

Yippeeeee!

Painting is a way of expressing one's thoughts and feelings.

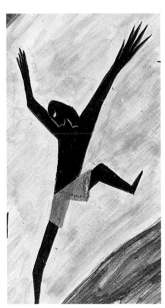

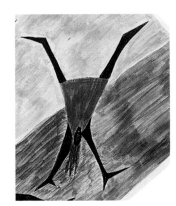

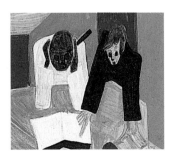

29

In 1941, Jacob Lawrence began a series of paintings called *The Migration*.

During the [first] World War there was a great migration north by southern African Americans. In every town they were leaving by the hundreds. . . . The trains were packed. . . . Injustice [was] done to African Americans in the courts. . . . They were poor. . . . Food had doubled in price. . . . [There was] child labor and a lack of education. . . . Where there had been a lynching, the people. . . left immediately.

Jacob's parents were part of this migration. He painted sixty scenes of African Americans traveling north.

(Here are three. Remember numbers 23 and 45?)

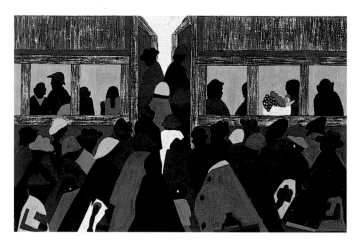

23. And the migration spread.

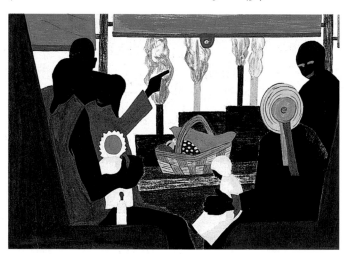

45. They arrived. . . in large numbers.

Up North, housing for the African Americans was a very difficult problem. They also found discrimination. . . . Race riots were very numerous. . . [Yet] in the North children had better education. . . the black people had freedom to vote.

58. In the North the African Americans had better educational facilities.

Then came good days for Jacob Lawrence.

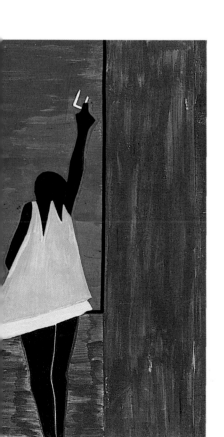

Gwendolyn Knight in the mid-1930s.

He married Gwendolyn Knight, an artist who also lived in Harlem. He became the first African-American painter whose work was sold in a major New York art gallery.

The Migration Series was exhibited by the Museum of Modern Art in New York City and across the United States.

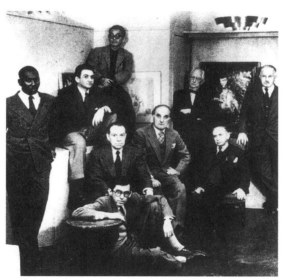

Jacob Lawrence, left, and other artists whose work was sold at Edith Halpert's Downtown Gallery, 1952.

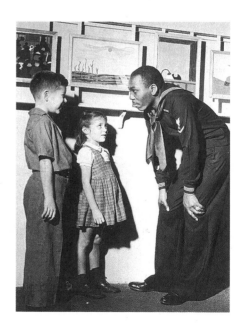

Jacob Lawrence and two fans at an exhibition of *The Migration Series.* Museum of Modern Art, New York City, 1944.

Jacob painted a fourth hero in *The Legend of John Brown.*

Jacob and Gwendolyn Lawrence traveled to New Orleans in 1941. There, Jacob created twenty-two scenes about the famous white man who gave his life to save slaves. With twenty-five black and white men, John Brown fought his final battle at Harpers Ferry, Virginia.

(Here are four scenes with the artist's original words. These are prints, created years after the original paintings were made.)

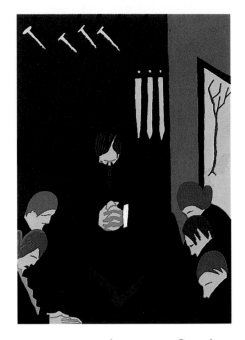

2. For 40 years, John Brown reflected on the hopeless and miserable condition of the slaves.

When subjects are strong, I believe simplicity is the best way.

■ Here, Jacob divided each picture into big, simple shapes of color. Then he added people and objects.

Which scenes have these shapes for depth, drama or mood? ↓

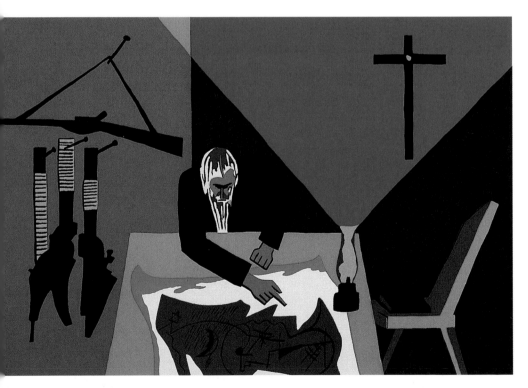

13. John Brown, after long meditation, planned to fortify himself somewhere in the mountains of Virginia or Tennessee and there make raids on the surrounding plantations, freeing slaves.

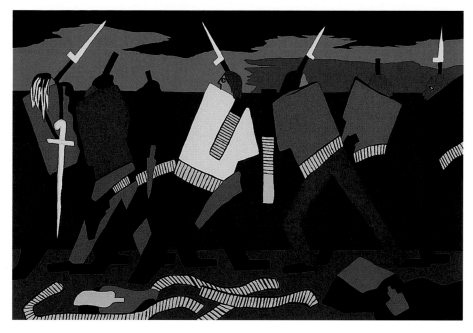

20. John Brown held Harpers Ferry for 12 hours. His defeat was a few hours off.

The inspiration to paint the Frederick Douglass, Harriet Tubman and John Brown series was motivated by historical events as told to us by the adults of. . . the black community. . . . Most exciting to us, the men and women of these stories were strong, daring and heroic. . . .

▦ Find the symbol of John Brown's belief, "that he was chosen by God to overthrow black slavery in America."

Find symbols of his belief "in attacking slavery by force."

Did you find these?

- Hands clasped in prayer
- Bible on a table
- Cross
- Rifles and cartridges
- Pistols in holsters
- Bayonets

■ **Read more about the adventures of John Brown. Write or tell his story in your own words.**
Then, draw a scene from his life using strong background shapes.

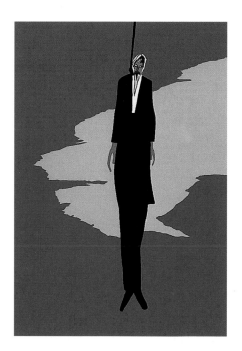

22. John Brown was found "Guilty of treason and murder in the 1st degree" and was hanged in Charles Town, Virginia [now West Virginia], on December 2, 1859.

Jacob Lawrence plans and paints each series in an amazing way.

This is one panel from a series of five scenes about George Washington Bush, an African-American pioneer and explorer who lived about 150 years ago. Here, Bush is leading a group of settlers over the Oregon Trail to the West Coast.

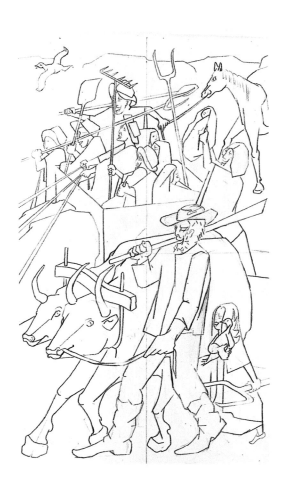

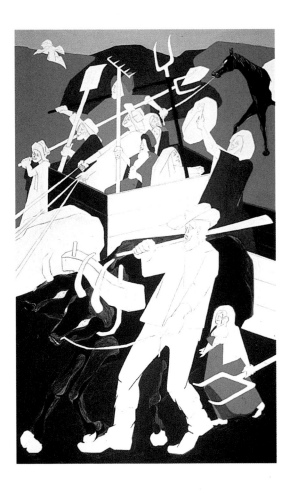

This is how Jacob Lawrence creates a series.
- He does lots of research. He reads. He takes notes.
- Then he writes a part of the story for each scene.
- Next, he sketches several ideas for each scene.
- He uses a pencil to draw the final plans for each scene on white paper or hardboard.

- Then he uses water-based paint and mixes colors he likes.
- He works with one color at a time. He paints the first color on each board in the series.
- Then he paints the second color on each board. Then he paints the next color and the next. (How many colors are there here?)

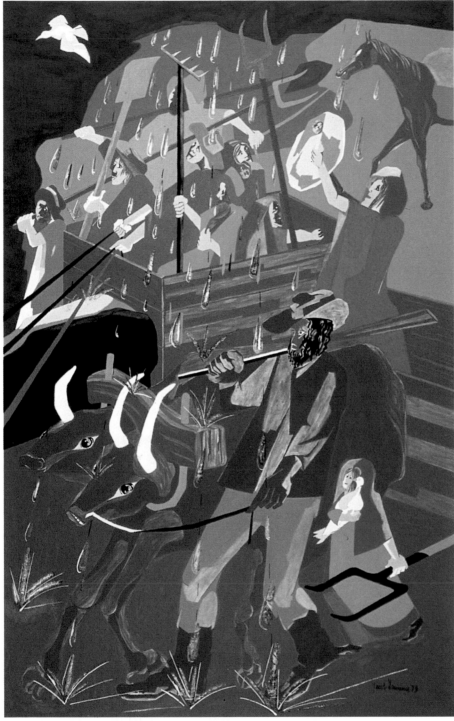

Panel 2, *In the Iowa Territory,* from the *George Washington Bush Series,* 1973.

- As he adds colors, he leaves some places white.
- Sometimes he paints one color over another.
- As the painting develops, he makes changes to create the picture he wants.

←

■ These settlers hope to farm the land.
Name the tools that the artist gives each one.
Find four oxen who will plow their fields.

▨ Point to places where Jacob Lawrence changed the scene as he worked on it. Point to ideas that he kept all along.

▨ Create your own series — Jacob's way or your own way.

Begin by reading stories.
Choose one that you really like.
Plan scenes that tell the story.
Write about each one. Draw and color the scenes on paper or hardboard.
Use pencils, crayons, markers, paint, cut-outs from magazines, or whatever you like. If a scene is not right, never mind. Change it or do another one.

During World War II, many African Americans fought for their country. Yet the struggle for equality at home was not over.

In 1941, when Jacob and Gwendolyn Lawrence made their first trip to the South, they encountered segregation. African Americans had to use separate (segregated) restaurants and hotels, and were made to ride in the back of buses.

Over the next twenty years, from the 1940s through the 1960s, a Civil Rights Movement was led by Reverend Martin Luther King, Jr. and others. Groups of citizens, both black and white, protested against segregation.

Here, they try to march over a bridge in Alabama, 1965. →

Marchers were often attacked with fire hoses, clubs and dogs.

■ Jacob does not show the battles fought to end segregation. Instead, he chooses symbols to represent the struggle. Notice the:
- troubled sky and dark, swirling waters that represent danger.
- snarling dog who stands for those who fought against the marchers.
- frightened marchers who symbolize all those who kept moving forward.

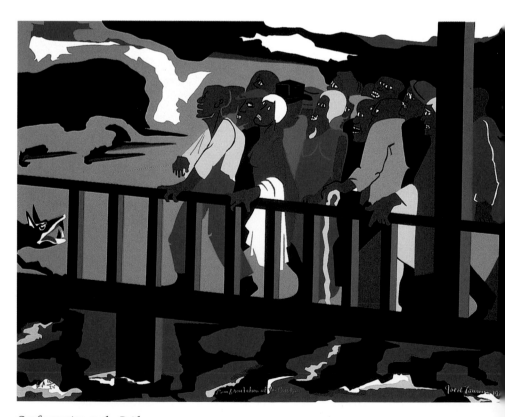

Confrontation at the Bridge, 1975.

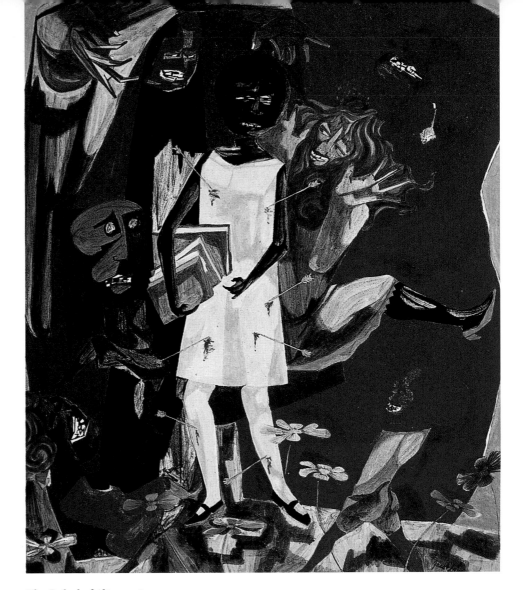

The Ordeal of Alice, 1963.

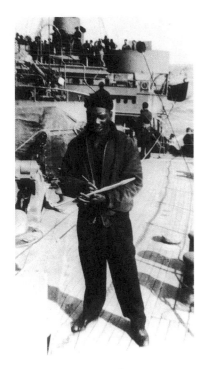

Jacob Lawrence in the Coast Guard, always drawing and painting, 1944. He served on the first integrated ship in the U. S. Coast Guard or Navy. African-American and white sailors served together, side by side.

I thought [these events were] part of the history of the country, part of the history of our progress; not of just the black progress, but of the progress of the people.

Southern schools had been segregated for years. White students attended separate schools from African-American students. Then, in 1954, a new law said that all public schools had to be opened to white *and* black children. ↑

■ Jacob Lawrence shows how a little girl named Alice feels when she tries to enter a white school. People yell horrible things at her. They seem like monsters to Alice. What expressions does the artist give the six monsters?

■ **Say it with symbols.**

The arrows in this painting are symbols of how words can hurt.
How would you picture someone being hurt by teasing and taunting?

Jacob Lawrence had become a famous painter of the American scene. Jimmy Carter invited him to his inauguration as President of the United States.

Jacob Lawrence decided not to show the inauguration in this painting.
Instead, he showed everyday people, of all races, watching the ceremony from the trees.

It was a very beautiful experience: the excitement. . . you get a feeling of the country. . . . You had a sense of history.

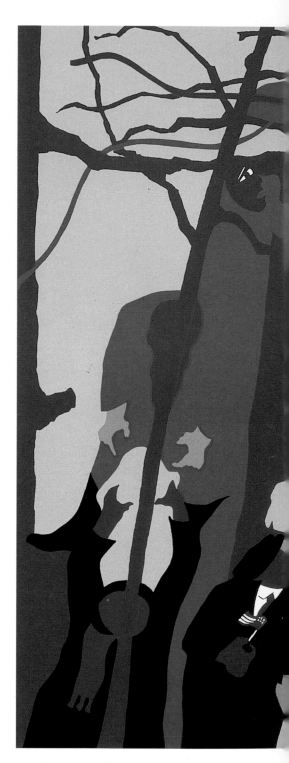

The Swearing In #1, 1977.

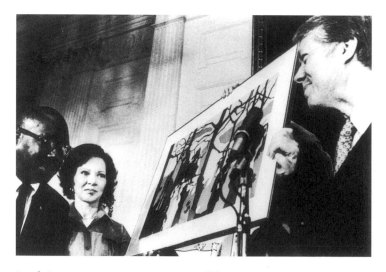

Jacob Lawrence presenting a print of this painting to President and Mrs. Carter, 1977.

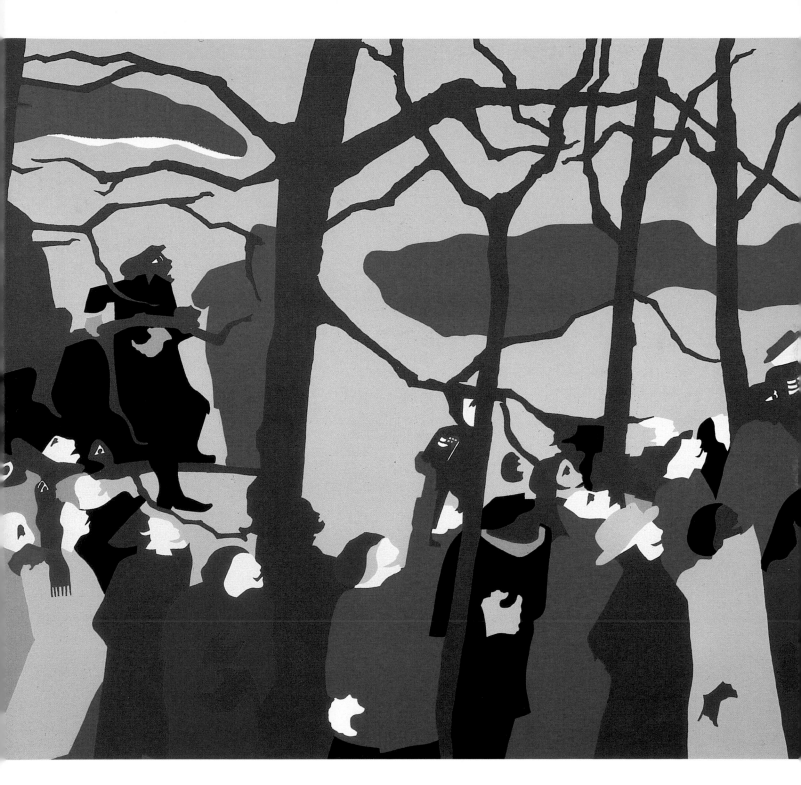

I looked behind me and way in the distance there were bare trees and people were up in these trees and they were applauding. . . . I see it as the most important ingredient of the election and the inauguration, and that's the people themselves.

Have you noticed that Jacob Lawrence has many ways of painting faces?

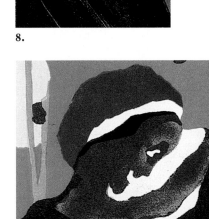

There's one face here that I do not like.

■ Test your memory.

First, look at the faces here. Which face is:
- painted brown over brown?
- brown with blue eyes?
- painted light over dark?
- a brown profile against white?
- red and shaped like a skull?
- pink with brown eyes and a brown nose?
- brown with a curly beard?
- just a dark shape?

← Now, look back through the pages of this book and find these faces in the paintings where they belong.

I.

2.

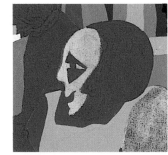

3.

4.

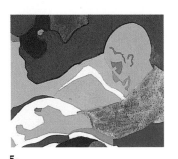

5.

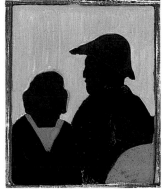

6.

8.

Answers:
1. On page 16.
2. On page 35.
3. On page 11.
4. On page 5.
5. On page 11.
6. On page 2.
7. On the cover and page 42.
8. On page 16.

40

In recent years, Jacob Lawrence has designed enormous murals.

He creates these wall designs on steel panels.

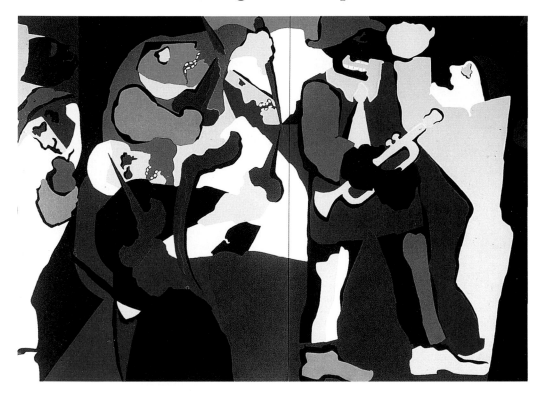

A detail from the large mural, *Theater*, 1985.

Imitate the incredible faces the artist gave these theater performers:

←

- a red-eyed actor.
- a trumpet player.
- a clown.
- masked actors.
- creatures with knives.

(Remember how Jacob Lawrence loves the theater?)

This is part of one mural ↑
from the University of Washington.
Jacob called it *Theater*.

■ **Act out!**

As a teenager, Jacob loved to make masks. Make your own mask of a character here. Make a costume of many colors. Put it all on, create a skit and act it out.

Have you guessed that Jacob Lawrence loves to picture tools — and people using tools?

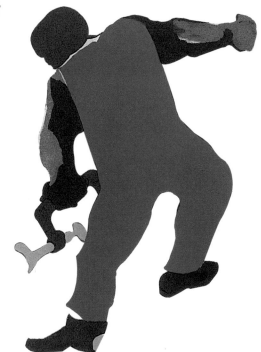

■ He paints lots of pictures of workers. Discover all the tools they are using here:
• Drills and hammers.
• Carving knife and fork.
• And?

Builders — Man on a Scaffold, 1985.

■ You can see that the artist gives his workers huge shoulders, arms and hands to show strength and force. Outline with your hand:
• big, rounded shoulders.
• big, square shoulders.
• bulging muscles.
• powerful hands.

Here we are again!

The Builders [paintings] came from my own observation of the human condition. . . .
I like the symbolism. . . . I think of it as. . . aspiration, as a constructive tool. . . building.

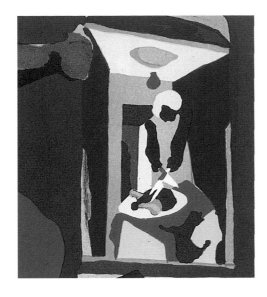

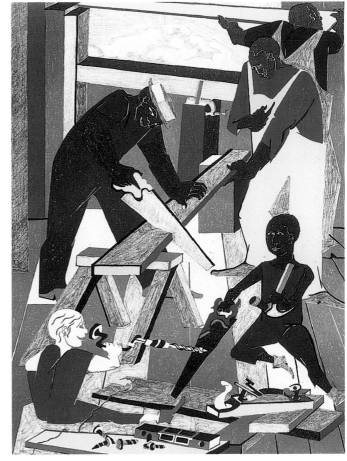

The Workshop, Builders #1,
1972.

I'll trade a drill for
your hammer.

Remember me
from page 23?

■ Be a builder.

Jacob Lawrence likes to
show children in his
pictures.
Make a picture of yourself
building something
fantastic with wood, using
your fantastic muscles.

Jacob shows the texture of
wood in his paintings. Try
showing the texture of
wood in your picture, too.

Let's end with a wonderful puzzle-like picture.

I've always liked people at play and people at work.

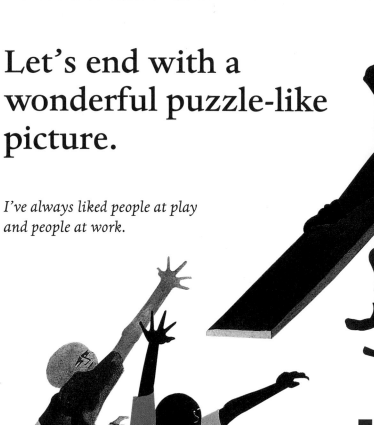

■ This painting vibrates with all the things Jacob Lawrence has loved for years. Try to untangle them:
• bits of Harlem.
• entertainers and dancers.
• builders and tools.
• big blocks of solid color.
• basketball players.
• and . . . ?

■ Jacob Lawrence's paintings express the joy of becoming skillful, working together and making others feel great. Which character in this painting do you think best expresses these feelings? →

■ Make a BIG, COLORFUL picture of you and your friends having a great time. (Will you add shiny paper? glitter? day-glow ribbons? confetti?)

Jacob and Gwendolyn Lawrence, 1990. Gwendolyn is also a fine artist, and she is an inspiration and help to Jacob.

Builders — Red and Green Ball, 1979.

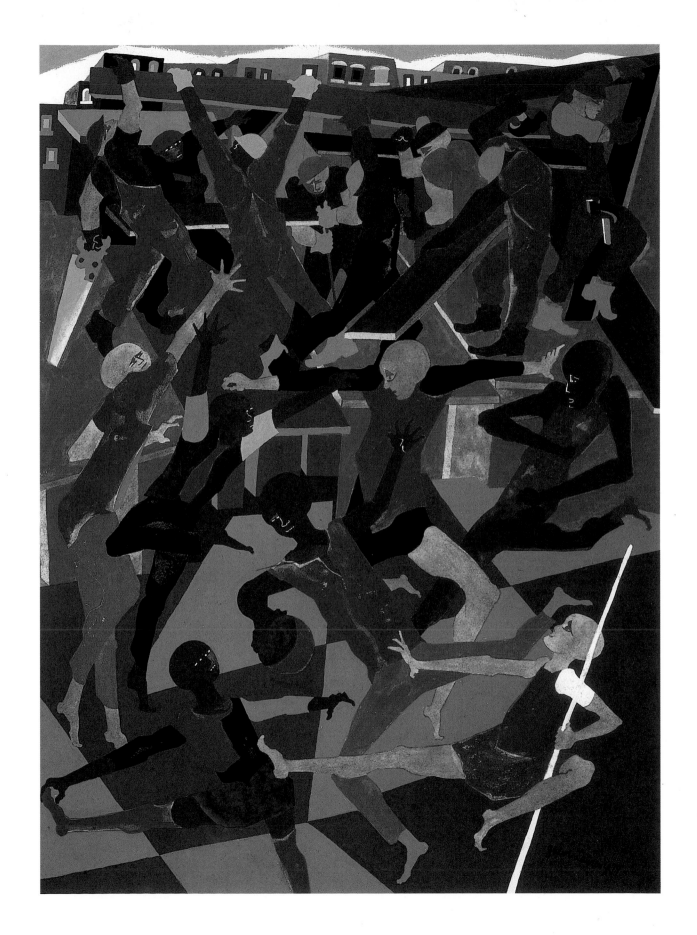

More About Jacob Lawrence

Jacob Lawrence was born in 1917
in Atlantic City, New Jersey.
He lived in Harlem for many years
and now lives in Seattle.

When Jacob Lawrence was growing up, Harlem was a renowned center for African-American writers, artists and jazz musicians. Talk about the great civilizations of Africa and about outstanding African Americans, such as Frederick Douglass and Harriet Tubman, could be heard throughout Harlem. There was talk, too, about the discrimination and injustice suffered by black people.

In the public library at 135th Street, Jacob Lawrence heard lectures about black culture, joined the history club and entered the Harlem Art Workshop. In the library's Schomburg collection, Jacob devoured books that inspired the many series of paintings that have made him famous.

From the age of fifteen until he was twenty-two, Jacob Lawrence studied with a Harlem painter, Charles Alston. Alston obtained a scholarship for his student to study for two years at the American Artists School in lower Manhattan. At nineteen, Jacob produced his first painting series, *Toussaint L'Ouverture,* forty-one scenes featuring the hero of Haiti. Jacob's first big break came in 1939, when the Baltimore Museum of Art devoted an entire room to this series.

Augusta Savage, a sculptor in Harlem, saw that Jacob Lawrence could not work at several part-time jobs and still become an artist. She took him to the Federal Art Project, part of President Franklin D. Roosevelt's Works Progress Administration (WPA), where support was given to artists on welfare while they produced works of art. Artists were required to turn in at least two works of art every six weeks. In 1939 and 1940, WPA funds enabled Jacob Lawrence to produce the *Frederick Douglass* and *Harriet Tubman* series, sixty-three paintings in all — a monumental achievement. In style and content, there is nothing like these series in American painting.

His style, from the start, was very much his own. From the time Jacob Lawrence was a youngster, he studied works of art in museums and books: ancient Egyptian wall paintings, European paintings by artists such as Goya and Daumier, and murals by modern Latino painters such as Orozco. Yet, his own way of designing bold shapes painted in strong colors — sometimes called *collage cubism* — was like no one else's. It is still unique today.

In 1940, Jacob Lawrence won a Rosenwald fellowship, rented a studio and began research on the migration of southern African Americans to northern cities. "My parents were part of that migration." He and a fellow artist, Gwendolyn Knight, prepared a sixty-panel series commemorating this movement of people. "Gwen did more than gesso those panels. She gave a certain spirit. . . to the creative process. We talked a lot." The next year they were married. In 1941, the *Migration of the Negro* (now titled *The Migration Series*) was exhibited at Edith Halpert's Downtown Gallery. The Museum of Modern Art and the Phillips Collection each bought thirty panels, and Ms. Halpert added Jacob Lawrence to the gallery's roster of outstanding painters.

One series of paintings followed another: *The Legend of John Brown, The South After World War II, Struggle of the American People* and more. From the mid-1960s onward, Jacob Lawrence taught on both the East and West Coasts while producing his own paintings, prints, posters and illustrations of books as diverse as *Aesop's Fables* and John Hersey's *Hiroshima.* In 1971, Jacob was appointed as a full professor at the University of Washington in Seattle, where he and Gwendolyn live today. In recent years, he has produced large murals on enameled metal: *Games* for the Kingdome Stadium in Seattle, *Exploration* and *Origins* for Howard University, and *Theater* for the University of Washington. Among his many honors, Jacob was elected as a member of the National Academy of Arts and Letters and he has served a six-year term on the National Council of Arts.

During his long career, the hallmark of Jacob Lawrence's work has been his reverence for the dignity of the individual, his compassion for those who suffer and his belief that the struggle of African Americans is a symbol of the struggles of all humankind. And throughout, Jacob Lawrence has always returned to Harlem in his thoughts, work and gratitude. "I was praised and told that what I was doing had some value — by writers, other artists, teachers, librarians. It gave me a sense of value — right in the Harlem community."

In accepting a medal from the National Association for the Advancement of Colored People, Jacob Lawrence said, "If I have achieved a degree of success as a creative artist, it is mainly due to the black experience which is our heritage. . . . I was inspired by the black aesthetic. . . and stimulated by the beauty and poignancy of our environment. . . [and] that encouragement which came from the black community."

More About the Pictures

Cover
Builders — Man on a Scaffold (detail), 1985. Lithograph, 30" x 22½" (76.2 x 57.6 cm). Francine Seders Gallery, Ltd., Seattle, WA. Collection of PACCAR, Inc.

Inside Front Cover
The Frederick Douglass Series (detail), 1938–40. Casein on hardboard, 12" x 17⅞" (30.5 x 45.4 cm). Hampton University Museum, Hampton, VA.
The Studio (detail), 1977. Gouache on paper, 30" x 22" (76.2 x 55.9 cm). Seattle Art Museum, partial gift of Gull Industries; John H. and Ann Hauberg; Links, Seattle; and gift exchange from the estate of Mark Tobey.
Workshop (detail), 1972. Lithograph, 22½" x 17½" (57.2 x 44.4 cm). Francine Seders Gallery, Ltd., Seattle, WA. Photograph: Spike Mafford.

Page 1
The Studio, 1977. Gouache on paper, 30" x 22" (76.2 x 55.9 cm). Seattle Art Museum, partial gift of Gull Industries; John H. and Ann Hauberg; Links, Seattle; and gift exchange from the estate of Mark Tobey.

Pages 2–5
The Migration Series, #23, #45, 1940–41. Casein tempera on hardboard, 12" x 18" (30.5 x 46 cm). The Phillips Collection, Washington, D.C., which owns thirty of the paintings in this series. Photograph: Edward Owen.

Pages 6 and 7
Rooftops (No. 1, This is Harlem), 1943. Gouache with pencil underdrawing on paper, 14" x 21" (36.5 x 55.1 cm). Hirshhorn Museum and Sculpture Garden, Smithsonian Institution. Gift of Joseph H. Hirshhorn, 1966.

Pages 8 and 9
Grand Performance, 1993. Lithograph, 26½" x 20¼" (67.3 x 51.4 cm). Francine Seders Gallery, Ltd., Seattle, WA. Photograph: Spike Mafford.

Page 11
Schomburg Library, 1987. Gouache on paper, 30" x 22" (76.2 x 55.9 cm). Francine Seders Gallery, Ltd., Seattle, WA. Photograph: Chris Eden.

Pages 12 and 13
The Toussaint L'Ouverture Series, 1937–38. Tempera on paper, 11" x 19" (28 x 48 cm). Amistad Research Center's Aaron Douglas Collection, Tulane University, which owns all forty-one of the paintings in this series.

Pages 14–29
The Frederick Douglass and *Harriet Tubman Series*, 1938–40. Casein on hardboard, 17⅞" x 12" (45 cm x 30.5 cm). Hampton University Museum, Hampton, VA, which offers all sixty-three paintings in its book, *Jacob Lawrence: The Frederick Douglass and Harriet Tubman Series of 1938–40*, by Ellen Harkins Wheat, 1991.
In Jacob Lawrence's wonderful book for young people, *Harriet Tubman and the Promised Land*, you can see fifteen additional Harriet Tubman paintings. New York: Simon & Schuster, 1993.

Pages 30–31
The Migration Series #58, 1940–41. Tempera on gesso on composition board, 18" x 12" (45.7 x 30.5 cm). The Museum of Modern Art, New York, Gift of Mrs. David M. Levy. The museum owns thirty paintings from the series.
In Jacob Lawrence's book for young people, *The Great Migration: An American Story*, you can see all sixty paintings in this series. New York: Harper Collins, 1993.

Pages 32 and 33
The John Brown Series, 1942. Screenprint, 20" x 25⅞" (50.8 x 65.7 cm). Francine Seders Gallery, Ltd., Seattle, WA. Photograph: Spike Mafford.
The Detroit Institute of Arts owns all twenty-two of the original paintings in this series.

Pages 34 and 35
In the Iowa Territory, Panel 2 from the *George Washington Bush Series*, 1973.
Casein gouache on paperboard, 31½" x 19½" (80 x 49.5 cm). Courtesy of Washington State Capital Museum, Olympia, Washington. Photograph: Grace Carlson and University of Washington Art Slide Library.

Page 36
Confrontation at the Bridge, 1975. Screenprint, 19½" x 25⅞" (49.5 x 65.7 cm). Francine Seders Gallery, Ltd., Seattle, WA. Private Collection.

Page 37
The Ordeal of Alice, 1963. Egg tempera on hardboard, 19⅞" x 23⅞" (50.5 cm x 61 cm). Francine Seders Gallery, Ltd., Seattle, WA. Collection of Gabrielle Reem Kayden and Herbert Kayden.

Pages 38 and 39
The Swearing In #1, 1977. Screenprint, 20" x 30" (50.8 x 76.2 cm). Francine Seders Gallery, Ltd., Seattle, WA. Photograph: Spike Mafford.

Page 41
Theater (detail), 1985. Porcelain enamel on steel, 4'-3" x 41'-6" (1.30 x 12.65 m). Courtesy of University of Washington, Seattle, Washington.

Page 42
Builders — Man on a Scaffold, 1985. Lithograph, 30" x 22½" (76.2 x 57.6 cm). Francine Seders Gallery, Ltd., Seattle, WA. Collection of PACCAR, Inc.

Page 43
The Workshop, Builders #1, 1972. Lithograph, 22½" x 17½" (57.2 x 44.4 cm). Francine Seders Gallery, Ltd., Seattle, WA. Photograph: Spike Mafford.

Page 45
Builders — Red and Green Ball, 1979. Gouache on paper, 30" x 22" (76.2 x 55.9 cm). Francine Seders Gallery, Ltd., Seattle, WA. Photograph: Chris Eden.

Inside Back Cover
Self-Portrait, 1977. Gouache on paper, 23" x 31" (58 x 79 cm). National Academy of Design, NY.